FASHION

First published 2022 by order of the Tate Trustees
by Tate Publishing, a division of Tate Enterprises Ltd,
Millbank, London SW1P 4RG
www.tate.org.uk/publishing

A catalogue record for this book is available from the British Library
ISBN 978 1 84976 717 0

Distributed in the United States and Canada by ABRAMS, New York

Library of Congress Control Number applied for

Senior Editor: Alice Chasey
Series Editor: James Finch
Production: Juliette Dupire
Picture Researcher: Roz Hill
Designed by Narrate + Kelly Barrow
Colour reproduction by DL Imaging, London
Printed in Wales by Cambrian Printers

Front cover: John Singer Sargent, *Study of Mme Gautreau* c.1884 (detail),
see p.32

Measurements of artworks are given in centimetres, height before width,
before depth.

FASHION

SHAHIDHA BARI

Director's Statement

'Look Again' is a bold new publishing programme from Tate Publishing and Tate Britain. In these books, we are providing a platform for some of the most exciting contemporary voices writing today to explore the national collection of British art in their own way, and reconnect art to our lives today. The books have been developed ahead of the rehang of Tate Britain's collection, which will be launched in 2023 and will foreground many of the artworks discussed here. In this second set of texts – The Sea by Philip Hoare, *Complicity* by Jay Bernard, *Fashion* by Shahidha Bari and *Visibility* by Johny Pitts – we are offered unique perspectives on a wide range of artworks across British history, and encouraged to look closely, and to look again.

Alex Farquharson, Director, Tate Britain

Grayson Perry wore a frock when he won the Turner Prize in 2003, accepting his award at the ceremony at Tate Britain in the guise of his alter ego Claire. 'It's about time a transvestite potter won the Turner Prize,' he announced brightly. His exhibits at that year's show had included an oversized doll's dress designed for an adult, titled *Coming Out Dress* – a ruffled, ruched and frilled affair in various pastel shades and cheerfully dotted with phallic imagery. The dress that Perry wore that night at Tate Britain – an outfit modelled on Little Bo-Peep, cut from lilac satin, appliquéd with yellow rabbits and complete with puff sleeves, petticoat, a turquoise collar, bow and trim – would itself become an exhibit in a show exploring Perry's transvestism over a decade later.[1]

How we dress can be a deeply personal matter. In general, we take dress as an expression of individuality or identity. Can dress also be the object of deeper artistic enquiry, and can it tell us something more about the societies in which we live? These are the questions at the heart of this book. For Grayson Perry, dress seems to be all things: a personal expression, a daring act of public display and an artistic experiment too. But perhaps the same can be said for lots of forms of dress in art. Perry's work is only one of the most recent iterations of this deep connection between dress and art.

The title of this book is *Fashion*, so let's start our thinking about dress and art here. It's true that the word 'fashion' is often taken to signify only the most exclusive end of dress and design (and, when pronounced mockingly, brings to mind David Bowie's 1980 song about fashionable posturing: 'Fashion! / Turn to the left / Fashion! / Turn to the right / Oooh, fashion!'). In recent years, though, blockbuster museum fashion shows – such as the *Savage Beauty* Alexander McQueen exhibition at the Metropolitan Museum of Art in New York (2011), *The Fashion World of Jean Paul Gaultier* at the Montreal Museum of Fine Arts (2014), Christian *Dior: Designer of Dreams* at the Musée des Arts Décoratifs in Paris (2017–18) and *Balenciaga: Shaping Fashion* at the Victoria and Albert Museum in London (2017–18) – have become fixtures in the art calendar, and are often visually beautiful as well as commercially popular.

In some ways, this is not a new phenomenon. There's a long-standing relationship between artists and the high fashion world. The French artist Henri Matisse was known for his habit of snatching up dresses from end-of-season sales at the Paris couture houses in the *quartier* around the rue La Boétie – see the two dresses, one in yellow and the other in blue, orange and green tartan taffeta visible in his *Deux jeunes filles, la robe jaune et la*

"CAN DRESS ALSO BE THE OBJECT OF DEEPER
ARTISTIC ENQUIRY, AND CAN IT TELL US
SOMETHING MORE ABOUT THE SOCIETIES
IN WHICH WE LIVE?"

robe écossaise 1941.[2] More recently, artists and
fashion designers have continued to collaborate or
influence each other: in 2012 Louis Vuitton released
a ready-to-wear and accessories collection based
on the work of Japanese artist Yayoi Kusama, and
in 2020 Hedi Slimane worked with New York artist
David Kramer. The most potent historical example of
art influencing fashion might well be that of the work
of Dutch modernist Piet Mondrian and the French
couturier Yves Saint Laurent – we'll look more at
that later. It's worth noting, however, that the traffic
isn't only one-way: artists can influence designers,
but dress itself can be the driver of avant-garde art.
In 1927, Sonia Delaunay, the great Ukrainian-French
artist of geometric abstraction, gave a lecture at
the Sorbonne in Paris, *The Influence of Painting on*

the Art of Clothes. 'If painting has become a part of our lives', she observed, 'it is because women have been wearing it.'[3] If she was right to claim that avant-garde fashion sometimes precedes avant-garde art, then we might need to look more closely at how fashion is represented in art too. We might need to ask what we can we learn about art by looking at clothes.

But it can be hard to really *think* about clothes. Sometimes they can dazzle us into unthinking submission. High fashion, in particular, is a beautiful seduction, and art often reminds us of this. Anyone who has gazed at Vermeer's ermine-trimmed aristocrats, Tissot's demurely striped dames and Sargent's society belles will know this. But in this book, I also want to encourage you to think about the everyday dress that features in so many of the works selected here. Ask yourself what we can learn by attending to the turban on the head of a footman, the fabric gathered in the lap of a seamstress or the pleats of a dress swirling around the neck of a girl walking on her hands on a beach. You might be surprised by the insights that come of these questions – and that thinking about dress can take us into the heart of social life, cultural debate and political history.

BLUESTOCKINGS AND SEAMSTRESSES

Let's start by comparing two paintings at Tate Britain. The first, by the Swiss painter Angelica Kauffman, depicts an unnamed sitter in a blue gown, and is dated c.1775 (p.14); the other is a later portrait of a woman sewing by candlelight, *The Sempstress* 1846, by the English artist Richard Redgrave (p.15).

Kauffman, one of the most celebrated painters of the eighteenth century, was also a founding member of the Royal Academy of Arts in London – the first and foremost training school for artists in England. In fact, she can be seen in the artist Johann Zoffany's portrait of *The Academicians of the Royal Academy* 1771–2 – a kind of wryly observed school photograph – which depicted the various gentlemen members, posers and painters alike, crowded into a life drawing class amid the backroom clutter of plaster casts and packing cases. The social mores of the time, however, decreed that woman artists were not permitted to attend classes like the one Zoffany depicted, and so poor Kauffman is represented as one of two half-finished portraits hanging on a drab back wall (alongside her fellow artist, and the only other female founder, Mary Moser). But Kauffman's exclusion from life drawing had other repercussions:

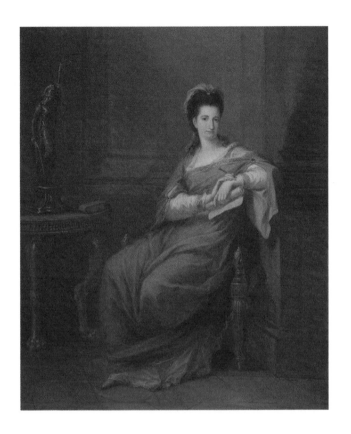

Angelica Kauffman, *Portrait of a Lady* c.1775, oil paint on canvas,
91 x 77, Tate

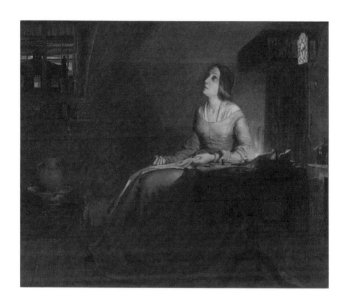

Richard Redgrave, *The Sempstress* 1846, oil paint on canvas,
63.9 × 76.9, Tate

"'IF PAINTING HAS BECOME A PART OF OUR LIVES, IT IS BECAUSE WOMEN HAVE BEEN WEARING IT.' SONIA DELAUNAY"

it meant that her work largely consisted of self-portraits and portraits of women, like the one we see here.

Perhaps because of the marginalisation of women in this period, Kauffman's portraits of women are sympathetic, the sitters often depicted as figures not only of beauty but of learning. Here, the model is presented in loose robes that are classical in style rather than fussily fashionable. Half-turned to the viewer, she steadily returns our gaze. Her arms rest easily on the chair; one hand holds a scroll, the other a writing implement, ready to set to work. The statue of Minerva, Roman goddess of wisdom, watches over her. Who is the mysterious subject of this painting? Suggestions include the

historian Catherine Macaulay (1731–91) and the writer Elizabeth Montagu (1718–1800). Both women were famed eighteenth-century intellectuals belonging to the Bluestocking Circle that emerged in England around 1750, and the sitter's blue dress might be hinting at that affiliation. Often learned and privileged in background, the Bluestockings refused to accept the exclusion of their sex from 'the republic of letters', staking a claim to intellectual life and the right to education at a time when few women could do so. They aspired to be writers, artists, historians and thinkers. Although the term 'Bluestocking' initially referred to both men and women, it would later become a specific designation for intellectual women (much like the term's French equivalent, *bas bleu*), and would subsequently be used as a pejorative, a way to jeer at women's intellectual ambitions. The word possibly refers to the proclivity for formal black silk stockings among fashionable elites. Whatever the case, and while we can't see the sitter's stockings in Kauffman's painting, the classical blue dress demands our attention and subtly signals the possibility of a deeper intellectual life.

By contrast, Richard Redgrave's *The Sempstress* tells a different story, this time about working women's lives. The painting is one of a series of sentimental images that plead the case of

impoverished labourers like the seamstress, who in this case labours, seemingly day and night, over a blouse by the dim light of a single candle. Redgrave composed the image after reading a poem by Thomas Hood, 'The Song of the Shirt' (1843), which relates the plight of seamstresses 'In poverty, hunger and dirt / Sewing at once, with a double thread, / A Shroud as well as a Shirt'.[4] Twenty years later, on 17 June 1863, an anonymous young seamstress would write a letter to the *Times* in London, beginning: 'Sir, — I am a dressmaker, living in a large West-end house of business. I work in a crowded room with twenty-eight others. This morning one of my companions was found dead in her bed, and we all of us think that long hours and close confinement have had a great deal to do with her end.'[5] The case of twenty year-old seamstress Mary Ann Walkley, who had died of overwork after sewing for almost twenty-seven hours without relief for the court dressmaker Madame Elise, would become a cause célèbre: Karl Marx would even cite the details of her appalling death in his famous economic treatise, *Capital*, arguing that seamstresses like Walkley were among the spectres of capitalism – a ghoulish army of voiceless workers who had suffered untimely deaths as a result of the hazardous conditions of their labour.[6] In Marx's time, as now, young women made up the majority proportion of the textile-working poor: 'Their fingers

ulcerated from handling arsenic-based dyes
and their lungs clogged with cotton dust, they
were the victims of the experimental industrial
chemistry and mechanical mass production that
characterised the nineteenth century, and of which
Redgrave's simple, sentimental portrait stands now
as a damning indictment.'[7]

A BLACK MODEL C.1830–40 BY AN UNKNOWN ARTIST AND *BARON NAGELL'S RUNNING FOOTMAN* BY OZIA HUMPHRY C.1795

Sometimes clothes can be the key that unlocks the story behind a portrait. These two portraits at Tate Britain represent two men of colour – one an unknown model painted in oils by an unknown artist from c.1830–40 (p.22), and the other, familiarly known as *Baron Nagell's Running Footman*, a pastel by the English painter Ozias Humphry c.1795 (p.23). They are profoundly important works, reflecting back to the viewer a global and multiracial picture of the eighteenth century. Both portraits depict Black men who seem to be wearing ornate or 'exotic' dress. On closer inspection, however, these are really significantly different portraits of two very different men.

Take their expressions, for instance. The sitter in Humphry's picture has been posed traditionally, seated perhaps, side on to the viewer. His chin tilted upwards, he gazes confidently into the middle distance. The unknown artist's model, by contrast, seems to stand without self-consciousness, the angle of his left arm and the relaxed position of his right hand more natural. He meets our gaze more directly, too, but somehow without challenge or fear. Both men wear colourful turbans, but notice

"SOMETIMES CLOTHES CAN BE THE KEY THAT
UNLOCKS THE STORY BEHIND A PORTRAIT."

how the Running Footman's is bulbous, heavy
and ceremonially set off with puffed feathers.
The turban of the unknown model seems more
carefully wound, less internally structured, and trails
slightly where it is tied off low and close to his left
ear. This is a turban that looks worn, one that has
been wound and unwound, time and again. What
do these small distinctions tell us? Perhaps they
reveal something about the authenticity of ethnic
dress contrasted with the affectation of ornate
dress in aristocratic portraiture.

Baron Nagell – his full title Baron Anne Willem
Carel van Nagell van Ampsen – was the Dutch
ambassador to London from 1788 to 1795. When
he made his first appearance at the London

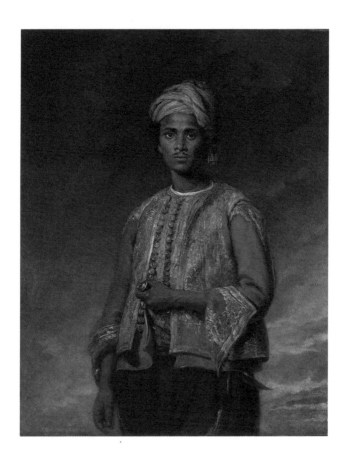

Unknown, *A Black Model* c.1830–40, oil paint on canvas, 128.3 × 101.6, Tate

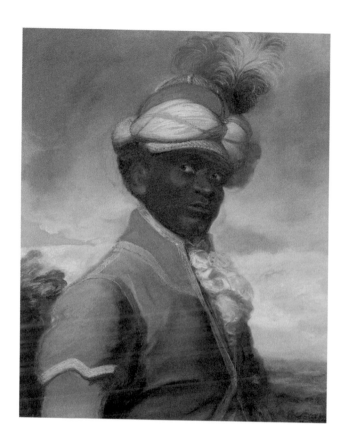

Ozias Humphry, *Christiaan van Molhoop* c.1795, pastel on paper, 72.5 × 61, Tate

court in March 1788, a spectator noted that 'he makes a splendid appearance with his footmen in scarlet and silver, and a gay page or Running footman was vastly well Received'.[8] It was an art historian specialising in dress, Aileen Ribeiro, whose research uncovered the conventions of the uniforms those running footman would have worn – their feathered headdresses, silver braided caps and turbaned silk – and that the blue, reddish orange and white of their livery corresponded to the colours of the Dutch flag.[9] At various times in the history of Humphry's portrait, its sitter has been described as 'the Artist's Black Servant' and 'An African Prince', but it's the dress history that allows us to specify his role and his relationship to the Dutch empire.

But what of his own history? This is so often the compelling, unanswered question beneath portraits of unnamed people of colour. Dutch genealogist Marjolijn Flobbe has recently named the sitter as Christiaan van Molhoop (1733–1816), a known servant in the baron's family, who was born and enslaved in Suriname, baptised in Amsterdam and died aged eighty-three in Ampsen Castle.[10] What does this new knowledge do for our understanding of the portrait? It gives this real person the dignity of his true history. It also lays bare the complex colonial legacies of national collections. More

than this, it challenges us to question the narrative signalled by this model's dignified uniform, prompting us to ask whose story is being told in the garments a model is made to wear.

But what of the unnamed Black model painted by the unknown artist? There are clues in this painting still waiting to be understood. Perhaps you're the viewer to start to unravel the mystery.

ART INFLUENCING FASHION, FASHION INFLUENCING ART

'The masterpiece of the twentieth century', Yves Saint Laurent declared, 'is a Mondrian.'[11] His Autumn/Winter 1965 collection, devoted to Mondrianesque geometry, placed the shapes, colours and planes of the Dutch artist's ascetic vision of modernism on the form of a woman's body. Mondrian himself, back in 1931, had had a sense of this future, observing: 'Not only does fashion accurately reflect an era, it is also one of the more direct forms of visual expression in human culture.'[12]

Saint Laurent's collection consisted of wool jersey dresses, inlaid without visible seams, an effort to mimic in textile the qualities he perceived in Mondrian's canvases (p.27). As a youngster, he had received from his mother a copy of Michel Seuphor's Piet Mondrian: Sa vie, son œuvre (1956), and the book's influence would surface in that landmark 1965 collection, and be reprised again in his haute couture collection for Spring/ Summer 1980. Saint Laurent saw in the shift dress, with its resistance to the curve, the possibility of a version of Mondrian's dignified plane – the perfect canvas for simple, unadulterated and flat colour. On such a surface, colour and line could be imbued with meaning.

Yves Saint Laurent, *Mondrian dress* A/W 1965 collection

"'THE MASTERPIECE OF THE TWENTIETH CENTURY', YVES SAINT LAURENT DECLARED, 'IS A MONDRIAN.'"

For Mondrian, colour was a form of thinking – something only understood in solid square or rectangular forms, delineated by black, which expressed a deep harmony, balance and proportion. The grid was an unyieldingly pure mode of abstraction. He called his approach to form and colour neo-plasticism – something not natural, but somehow absolute and truthful. By contrast, Saint Laurent's dresses were not entirely abstract – how could they be when they were intended to be worn by a woman? – but here he sought to fuse Mondrian's abstract ideal with the female form, recognising the harmony, balance and proportion that belonged to the art of dressmaking.

You can see the influence of Mondrian's grid in the work of Marjorie Jewel Moss, otherwise known as Marlow Moss. A disciple of Mondrian, Moss makes the structural quality of the grid visible in her three-dimensional riffs on his work. Take a look at her

Composition in Yellow, Black and White 1949 at Tate Britain (p.30). Here, a white canvas is lifted off the page by two areas of black. They, in turn, set off a golden yellow rectangle framed by white lines. 'I am no painter,' Moss said of herself; 'I don't see form, I only see space, movement and light'.[13] It's a remarkable way to understand her work – not in terms of rigidity of form, only an articulation of space, movement and light.

For Moss, the spirit of radical freedom and the refusal to be restricted by conventional forms extended beyond the canvas: 'Art is – as Life – forever in the state of Becoming', she observed.[14] From 1919, she dropped her birthname, preferring to be known as 'Marlow', and adopted masculine dress and appearance. In the portrait photographs of Moss taken by Stephen Storm (the son of Moss's partner, the novelist A.H. Nijhoff) she resembles Fred Astaire, dressed up in a formal collar, cravat or riding jacket, her thin cropped hair slicked to the side. She is sharp-chinned, her expression by turns mischievous or faintly bemused; she is pictured propping her head on her hand, or toying languidly with a cigarette. It isn't necessary to connect Moss's gender nonconformity to her art, but it's possible to recognise a continuity in the freedom she was determined to express in both her work and her life.

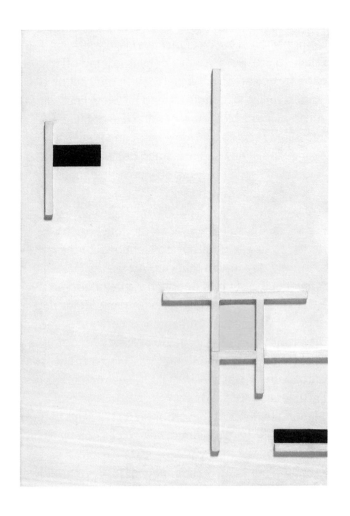

Marlow Moss, *Composition in Yellow, Black and White* 1949, oil and
wood on canvas, 50.8 x 35.6 x 0.6, Tate

"'NOT ONLY DOES FASHION ACCURATELY REFLECT AN ERA, IT IS ALSO ONE OF THE MORE DIRECT FORMS OF VISUAL EXPRESSION IN HUMAN CULTURE.' MONDRIAN"

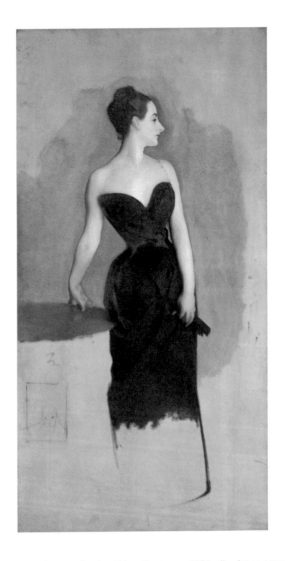

John Singer Sargent, *Study of Mme Gautreau* c.1884, oil paint on canvas, 206.4 x 107.9, Tate

JOHN SINGER SARGENT'S *MME GAUTREAU* 1884 AND *ELLEN TERRY AS LADY MACBETH* 1889

Walking through the Tate Britain collection, you will survey 500 years of how human beings have seen the world. It's not surprising that our eye is so often caught by spectacular gowns, sumptuous robes, the embellishment on a sleeve or the bold colour of a waistcoat, because clothes too are artistic visions of human possibility: what we can make, how we can look and who we can be. See, for instance, the preparatory studies for what will become John Singer Sargent's *Portrait of Madame X* 1884. The subject, Parisian socialite Amélie Gautreau, stands swathed in a black silk dress dramatically cinched at the waist, with the hint of a bustle behind her (p.32). In the finished portrait, Sargent would give her a train pooling at her feet, but here you can see that he is still experimenting with her pose, as though she were a fashion model. In this study, her face is inclined away from us, making it difficult to read, and so everything is expressed instead in the taut length of her throat, the line of her collarbone, her pale bared arms, and the expanse of alabaster skin that sinks into the sweetheart neckline of her dress.[15]

You can just about detect, in the study, one of the gold chains that form the straps of that dress.

"IT'S NOT SURPRISING THAT OUR EYE IS SO OFTEN CAUGHT BY SPECTACULAR GOWNS, SUMPTUOUS ROBES, THE EMBELLISHMENT ON A SLEEVE OR THE BOLD COLOUR OF A WAISTCOAT, BECAUSE CLOTHES TOO ARE ARTISTIC VISIONS OF HUMAN POSSIBILITY: WHAT WE CAN MAKE, HOW WE CAN LOOK AND WHO WE CAN BE."

A finished version of the portrait exhibited at the Paris Salon in 1884 scandalised viewers when it was noticed that Sargent seemed to have left the other strap carelessly slung off the right shoulder: 'One more struggle', wrote an excitable critic in *Le Figaro*, 'and the lady will be free'.[16] In reality, the straps were ornamental and Gautreau perfectly secured in a rigid bodice comprising a metal and whalebone frame. The furore, though, was enough to mortify the sitter, who forced a reluctant Sargent to return to the painting to realign the strap. The exposure that had been read as an outré marker of sexual freedom meant for Gautreau, in reality, social ostracism. This story lends the portrait a frisson, but for all the disapprobation there remains in this powerful portrait an enduring dignity, a sense of balance

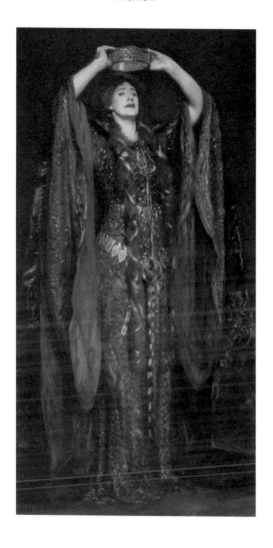

John Singer Sargent, *Ellen Terry as Lady Macbeth* 1889, oil paint on canvas, 221 x 114.3, Tate

and measure in its composition: a strength borne across the length of her bare rounded shoulders, a stretch as steady as a horizon.

Five years later Sargent would prepare a study of the famed actor Ellen Terry in her celebrated role as Lady Macbeth, in a production by Henry Irving at the Lyceum Theatre, London in 1888 (p.35). Sargent attended the opening night on 29 December, and his determination to capture something of Terry's mercurial performance can be seen both in her pose – powerfully upright, holding the golden crown above her head – and in her astonishing costume: a wide-sleeved, floor-length emerald gown embellished with gold embroidery and a thousand iridescent beetle wing cases. (The dress was apparently inspired by another worn by Lady Randolph Churchill, similarly trimmed with green beetle wing cases.) Terry herself was passionate about costume and worked closely with two women – both fascinating figures in their own right – to create her stage wardrobe: Ada Nettleship, who designed it, and Alice Comyns Carr, who crocheted the costume with a green wool and blue tinsel yarn. Comyns Carr recorded that it was designed to resemble 'soft chain armour ... and yet have something that would give the appearance of the scales of a serpent'.[17] Writing to her daughter Edith Craig,

Terry lamented that 'the photographs give no idea of it at all, for it is in colour that it is so splendid', and Sargent's portrait certainly gives us some sense of its theatricality and power.[18]

Wolfgang Tillmans, *Kate Sitting / if one thing matters, everything matters, installation room 2, 1995-1997* 1996, chromogenic print on paper, 40.6 × 30.5, Tate

PHOTOGRAPHING DRESS

It might not have been the medium for Terry's Lady Macbeth dress, but photography certainly has a place in the history of fashion art, particularly when we reach the contemporary period. Wolfgang Tillmans's photograph of Kate Moss *Kate Sitting* 1996 captures the spirit of the millennium and the seemingly artless nature of realist fashion photography, but also the powerful presence of iconic women (p.38). Kate Moss here follows in the line of Gautreau and Ellen Terry.

The two images I want to leave you with are not fashion photography per se, but photographic images that nonetheless remind us of the symbolic role of dress in our lives and its place in art history. Mona Hatoum's *Performance Still* from 1985/1995 is a curiously elliptical image of two bare feet on a pavement, tied to a pair of boots that drag behind them (p.40). It is oddly vulnerable, like a visual pun with a hint of tragedy. What do these boots mean? The image documents a performance by Hatoum in Brixton – an area of London with a history of police brutality and race riots – in which the artist walked barefoot through the streets with a pair of Dr. Marten boots tied to her ankles. The Dr. Martens, worn both by the British police and skinheads, serve as a shorthand for that experience of racist

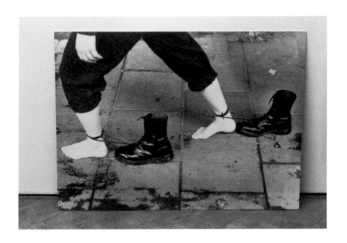

Mona Hatoum, *Performance Still 1985/1995,* gelatin silver print mounted on aluminium, 76.4 x 108, Tate

"IT IS ODDLY VULNERABLE, LIKE A VISUAL PUN WITH A HINT OF TRAGEDY. WHAT DO THESE BOOTS MEAN? "

violence. Rose Finn-Kelcey's *The Restless Image: a discrepancy between the felt position and the seen position* 1975 is a black and white photograph of what seems to be a young woman standing on her hands on a beach (p.44). Her pleated skirt billows around her as it is tugged by gravity, and her ribbon-tied espradilles poke impudently up into the air. Are these images of burden and freedom, of resistance and rebellion, of subversion and joy? It's up to you to decide.

"THINKING ABOUT DRESS CAN TAKE US INTO THE HEART OF SOCIAL LIFE, CULTURAL DEBATE AND POLITICAL HISTORY."

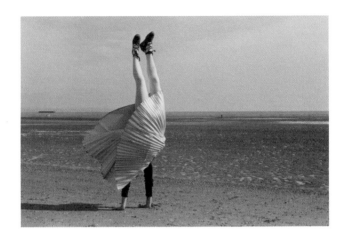

Rose Finn-Kelcey, *The Restless Image: a discrepancy between the felt position and the seen position* 1975, gelatin silver print on paper mounted on board, 66.4 × 101.4, Tate